CELTIC DESIGN

Aidan Meehan studied Celtic art in Ireland and Scotland and has spent the last two decades playing a leading role in the renaissance of this authentic tradition. He has given workshops, demonstrations and lectures in Europe and the USA, and more recently the Pacific North West from his home base in Vancouver, B.C., Canada.

CELTIC DESIGN

ANIMAL PATTERNS

AIDAN MEEHAN

with over 400 illustrations

THAMES AND HUDSON

artwork and calligraphy
copyright © 1992 Aidan Meehan

First published in the United States in 1992 by
Thames and Hudson Inc., 500 Fifth Avenue,
New York, New York 10110

Library of Congress Catalog Card Number 91-67307

Printed and bound in Great Britain

CONTENTS

INTRODUCTION

MITATION. REPETITION. Application. These are the three ways that any traditional art is learnt. We learn to speak by imitation. Therefore the proper way to learn a traditional art is by imitation, for a traditional art is a language, namely, a form language.

A N art form can be shared by many people across boundaries of culture, even of time itself; it re-mains intelligible to one who has learnt to read the form. It is this intelligibility of the form that

[7]

Fig. 1 Silver Gilt Buckle, Aker, S.E.Norway.

makes traditional art a language. In this volume of animal patterns ~ one of the most dynamic and popular types of Celtic design - you will find the repertory of animal designs to be the vocabulary, while the elements of construction constitute a grammar.

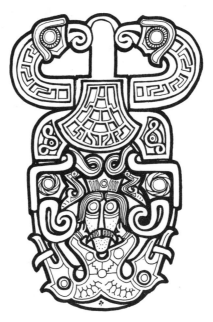

f.1 Northern European art carried over to
 Britain by Anglo-Saxons introduced
motifs that were to become the basis of
animal patterns in Celtic Christian manu-
scripts in the mid-seventh century. The
Aker buckle illustrates the Germanic style,
in the first half of the seventh century.

CHAPTER I

Origins of the Animal Style

THE ANIMAL PATTERNS
of Celtic Gospel book
illumination are a fusion
of many influences that
had come together during the time of
the migrations of the Germanic

tribes throughout Europe . The
'Northern Tradition' had already
brought together the Celtic, the
Romano - British , the Germanic and
Gallo - Roman styles ; all of which
may be found in the treasure of an
Anglian king (possibly Readwald ,
d . 625) , the famous Ship Burial of
Sutton Hoo.

f. 2 The great gold buckle from Sutton Hoo
 has serpents of Byzantine origin, com —
bined with eagle heads and woven animals of
German Style II .with strap bodies tending to —
wards split - ribbon . Notice the little animal
filler between the jaws of the beasties at the very
tip . Such a brooch could have come to a Celtic
abbey at any time in the seventh century .

Fig. 2 The Great Gold Buckle, Sutton Hoo, a.
 Detail of serpentine roundel, b.

← The roundel
 at the top is a
 very Celtic style of
 knot.

a.

The little beast
filling the jaws
of the animals at
the bottom is
←
also a device in
Celtic animal
designs.

b.

Fig. 3 Falcon and Duck, Sutton Hoo.

On the top of the Aker buckle, f.1, are
two bird heads, and on the sides two more
that are identical in style to that of the
falcon of the Sutton Hoo sporran shown
here, which presumably was made by an
early seventh-century master at the
court of East Anglia.

The falcon's head resembles the
head from the Aker buckle, f.4, c.

Fig. 4 Comparison of Bird Heads.

 a. From Sutton Hoo Sporran.
 b. From Sutton Hoo Buckle.
 c. From Aker Buckle.

a

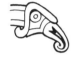 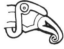 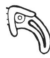 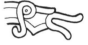

b

c

 Evidently the craftsmen in East Anglia used the same model – the Swedish Vendel style – as their Norwegian cousins in the seventh century.

Fig. 5 Two Eagles, Early Vendel Style.

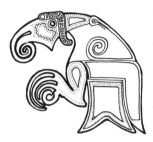

a

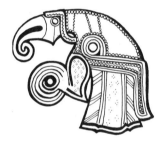

b

a. From the Sutton Hoo shield.
b. From a Gotland harness.

Fig. 6 Boars from Shoulder Clasp, Sutton Hoo.

THE Germanic eagle head flank-
ing the roundel atop the great
buckle from Sutton Hoo is not found in
the earliest fully illuminated manu-
script, the Book of Durrow, but that
this is so is surely an accident of hist-
ory only. If the Sutton Hoo beast was
alchemized into that of Durrow, but
the Eagle of Odin escaped the monks'
quill, I see no good reason to perpet-
uate the omission. For every motif
that made it into the final batch, there
are others that could yet be incorporated.
Such as these boars, for instance.

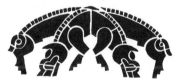

Compare these boars with those on the Aker buckle, f. 1 above.

Fig. 7 Chi-Rho Brooch from Linon, France.

This brooch from Linon, France, has two-headed dragons who intersect at a fyfot symbol alternating with boars'heads on the arms of a hexagon cross. The two arms enclosing the Greek letters Alpha and Omega form the diagonal cross or Greek Chi, X. The vertical arm forms the stem of the Greek Rho, R. Chi-Rho is the monogram of Christ, while Alpha and Omega, the Beginning and the End, is the emblem of Christ also.

fig. 8 Serpent Knot from Grave Slab, Hornhausen.

This twoheaded dragon knot from Germany

resembles the dragons on the Linon brooch.

fig. 9 Man between Two Beasts, Sutton Hoo.

Compare with the head in the Linon brooch.

The sun arrested between two devouring beasts is a Solstice symbol.

THE monks determined which ele-
ments of German art they could
adapt into the repertory of Celtic illu-
mination. Rather than restrict our-
selves to the forms they selected, in our own
day we should trace the roots of the
traditions and then, following the way
in which former syntheses were made,
create new ones of our own.

FOR example, while the spindle-
legged beast from Sutton Hoo did
not make it to Lindisfarne, it did to
Durrow. Likewise, the snakes on the
great gold buckle bypassed Durrow and
Lindisfarne, yet squiggle on the pages
of the Book of Kells.

T HE key to understanding a style is
to examine its roots in the period just
before its appearance, in this case the
first half of the seventh century. Germanic
animal designs of that time are the
seeds of the patterns that leap forth on
the carpet page of the Book of Durrow
and flourish in the Book of Lindisfarne,
c. 650 – 700. The main source is the trea-
sure trove of Sutton Hoo. whence we sur-
vey the art of Scandinavia, the Baltic
and Europe under the Germanic tribes
for sources of the Anglian motifs, and
Ireland and Britain for any indigenous
threads. As may be seen, motifs recur
like genes and are subject to mutation ,
permutation and hybridization .

Fig. 10 Mucking Belt Mount.

CHAPTER II

Belts, Buckles, Brooches...

HE TRADEMARK OF GER-
manic cloisonné is complex-
ity of cell form. Its shapes are
curved, wiggly and cobweb-
like. By contrast, the supposed cloisonné-
inspired Celtic step pattern is simple, and
based on a regular square dot grid. This con-
servative, quite archaic style is closer to the
pre-Saxon work of the early fourth cent-
ury. For example, the centre of the cross
carpet page in Lindisfarne is based on the
same square grid plan as that of the belt
mount from Mucking, f. 10, 11.

Fig. 11 Step pattern from Mucking and Lindisfarne.

Compare the step pattern from Lindisfarne, b, with the one from the Mucking belt mount, a. They are both laid out on a sixteen-square grid, but the Mucking pattern is set on the diagonal.

T he Mucking belt fittings are decorated with many of the elements of Gospel book ornament: step patterns, animal borders, key patterns, spirals. The belt mount itself bears an uncanny resemblance to the animal carpet page that opens the Gospel of St. John in the Book of Durrow: both have a border of animals that is wider at the top than the side, in order to enclose a central square. Yet the belt gear is either German mercenary's or early settler's work.

Fig. 12 Buckle and Counter Plate, Mucking.

The Mucking Buckle and
Counter Plate are Germanic adap-
tations of Roman Army gear,
possibly made in Roman Britain,
c. 400.

 The style is that of S.E. Eng-
land, early fifth century. The
head between two beasts is a Celtic
style of head, symbol of the
sun. The arrangement at the
bottom here is that of the sun being
devoured, the triumph of night over day, as the
sun approaches mid-winter. At the other end,
the counter plate shows the pair of beasts re-
treating, as in the lengthening of the day just
following mid-winter. The two pieces are
on opposite ends of the belt, brought together
when the belt is fastened.

Fig. 13 Griffin from Gundestrup Cauldron.

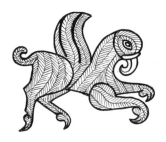

The winged griffin from the Gundestrup cauldron combines the two animals of the sun, the solar, golden-maned and royal lion, and the golden-plumed, equally majestic, all-seeing Lord of the sky, the eagle. This griffin is an early prototype of the odd quadruped with elongated jaws that we find in Germanic animal design.

Fig. 14 Shield Device, Bergh Apton.

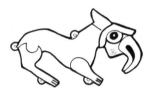

The Griffin may be guessed to be the distant archetype of this seventh-century four-legged monster off a shield from Bergh Apton, Norfolk.

Shield fixtures like this one and that of the eagle from the Sutton Hoo shield are rare finds, so they are thought to indicate a high rank, insignia of a king or chief perhaps, as in the manner of a heraldic crest. Ornaments such as this once had a practical, necessary function, conferring rank on the wearer.

THE dog, the bird and the serpent of Celtic art have their precedents in Germanic animal style, as we have seen in the brooches from Aker and Sutton Hoo. The dog from Mucking comes closer than either, for it is defined by an outline enclosing the interior of the body which is crosshatched, in a manner suggestive of enamelling. Also, the creature has spiral shoulder joints. This outline and spiral are found in the manuscripts, while the herring bone crosshatch remained in vogue in Ireland for half a millennium. It appears in motif-pieces such as that from Lagore, f. 62. That the herring bone hatch was also ancestral to the Germanic artist may be inferred from its use to great effect on the Bronze Age Gundestrup cauldron, f.13.

Belts, Buckles, Brooches ...

I T is an oversimplification to label the animal designs in the Book of Durrow as Anglo-Saxon, or Celtic spirals as exclusively Irish. We need to keep in mind the evidence that all of Britain and Ireland were long exposed to the same common heritage that had infused the continental mainland for centuries. Not only was iconography held in common, but techniques were also shared. The fusion of various traditions in the art of the Celtic Christian period was already developing before the fifth century. The Mucking belt gear must have come to Britain with those first few cohorts of German mercenaries invited to Britain by Vortigern, if it is Saxon art. Yet the chip-carving 'suggests a Roman hand at work in a German atelier'. Equally, it could be Romano-British work, taken as booty.

Fig. 15 Bow Brooch, Gotland, seventh century.

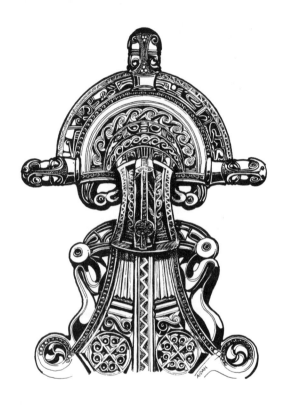

The horse heads in the upper semicircle might easily be mistaken for eighth-century Irish or Northumbrian work. Likewise, the extensions of the outer frame.

Belts, Buckles, Brooches...

IN many features comparable with later, Celtic metalwork – the same horse heads and the same convention of birds' heads that adorn the rim of the ninth-century 'Tara' brooch – the bow brooch from Gotland has two perfect triskeles that also hark back to the Celtic Bronze Age style of raised spirals, repoussé or cast. Between the triskeles in the lower frame are two cross-and-circle roundels, a square version of which appears below the cloisonné-like step patterns, f.12 and f.15.

MUCH has been made of the resemblance between Celtic art step patterns and cloisonnéd, Saxon models, specifically that of the Sutton Hoo sporran. But this piece is soldered-in solid, to emulate Celtic cell treatment, that is champlevé. Further, the boars are made to look Celtic by millefiori.

Fig.16 Alemannic Bow Brooch, Wittislingen.

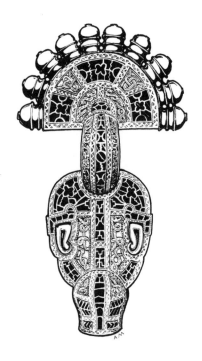

This piece illustrates the typical cloisonné
style of Germanic step patterns, cobweblike and
very abstract: the Vendel eagles on each side
may only be recognised by their hooked beaks!

Fig. 17 Snake Brooch , Oland , Sweden.

HIBERNO-SAXON' animal patterns from the Book of Durrow and Sutton Hoo are clearly linked , not as an Anglo-Saxon influence in an Irish foundation in Northumbria – in which case it would appear to be an overnight phenomenon – but as part of a pancontinental development in which both Celt and Teuton had long shared . This development grew out of a tendency of the Northern peoples of Europe to adapt classic ornament to traditional values of their own . From a figurative , sculptural , monumental art form was created an abstract , geometrically decorative form of language.

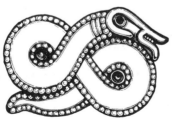

B Y overemphasizing the similarities
between the Book of Durrow and
Anglo-Saxon art we might suppose that
whoever produced the manuscript must
have been influenced by the Anglian court,
assuming the shoulder clasp and sporran
were made in a local work shop by an Angle.
S UCH a link is proposed partly on the
basis that the panel of step pattern
on the Sutton Hoo shoulder clasp bears a
resemblance to a carpet page described by
Janet Backhouse as

> very clear both in detail and in general
> conception. A multicoloured step pattern,
> its cells seemingly divided by walls of
> metal is used as the centre piece for the
> cross carpet page at the beginning of
> St. Mark in the Lindisfarne Gospels.

The simpler carpet pages in the Book of Durrow,
with their bold, large scale motifs and wide
borders, underline the relationship. A further
link with Durrow may be found in the border
of animal interlace surrounding the central
panel, whose long nosed, almost beaked ani-
mals are first cousins to the long snouted
creature on the St. John carpet page . . .

J. Backhouse The Lindisfarne Gospels, p.74, pl.52.

ANOTHER step in this line of thought is
the proposition that Irish mission-
aries to England were there introduced to
cloisonné jewelry and metalwork orna-
mented with interlaced animals

such as found in the Sutton Hoo ship burial
. . . the conception and the script . . . owe
everything to the Irish Foundation in
which this manuscript was written

and illuminated. This was probably
Lindisfarne itself, for it must have
been a centre fully exposed to the Anglo-
Saxon metalworkers' achievements of
the seventh century, a situation that is
unlikely to have arisen in Ireland...
such important new techniques as gold fili-
gree work and chipcarving were borrowed
from the Anglo-Saxons...

the traditional enamel and millefiori
designs are converted into rectilinear com-
partmentalized patterns derived from
those of Anglo-Saxon cloisonné jewelry.
J. Graham-Campbell, The Northern World,
Ed. David M. Wilson, p. 119.

HOWEVER, rectilinear celled step pat-
tern, chipcarving, garnet cloisonné
and filigree work were all over Europe,

Fig. 18 Cloisonné Shoulder Clasp, Sutton Hoo.

The animals here are difficult
to identify, apart from the criss-
crossed boars at the top. In the
border, the eagle head has a beak
more like an elephant's trunk,
attached to a body with no legs!

[35]

Fig. 19 Animal Head from the Cathach.

as were the Irish monks from as early as
the fifth century. Contacts with German-
ic Gaul forged long before make it seem
likely that Irish monasteries, such as Iona,
were addressing themselves to the inclus-
ion of Germanic animal interlace in the
development of Christian Gospel illumin-
ation. We see it already in the Cathach of St.
Columba, probably not the saint's own
hand, but certainly Irish and older than
Lindisfarne, if not even than Iona, dating
to around 550.

The Cathach of St. Columba, the first Irish illum-
inated manuscript contains this animal head.

Fig. 20 Animal Heads, Gotland Bow Brooch.

a The definition of the toes and the elongation of the jaws anticipate the treatment in the earliest manuscripts. The floppiness of the jaws is typical of early Germanic animal style. The two creatures above are descended from lions, the strokes behind their heads derived from the mane. The bodies are segmented and read as tail-hind leg-torso-foreleg-neck-head-lappet-eye-cheek-jaws.

b Floppy jawed heads, same brooch.

Fig. 21 Sword Pommel, Obervorshütz.

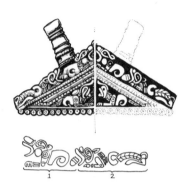

The fragment of a sword panel from
Obervorshütz, in Northern Hesse, is of
the first half of the fifth century, im-
mediately before the emergence of the
Germanic Animal Style I. Ultimate-
ly derived from the Roman tympa-
num, via Roman military gear, it
shows two lions, one disappearing
into the mouth of the one behind.

Fig. 22 The Snartmo Sword Pommel.

Germanic Animal Style I spread
rapidly northwards, and during the

A MEEHAN

sixth century emerged as a visual form
language of utter sophistication. The
pommel is but a wisp of a tympanum.

Fig. 23 Alemannic Goldfoil Cross, Hintschingen.

As we have seen on the Snartmo sword
pommel, the Roman lion has acquired
a beaked head, drumstick joints, cuff-
ed ankles and wrists, and three toes.
In the panel uppermost in the hilt is
a pair of biting beasts whose necks
cross over in a loop, thus heralding
the arrival of phase two of the German
animal style, animal interlace. The
Alemannic goldfoil cross here has
the same crossed, elongated jaws,
drumstick legs and three toes as the
griffin on the Snartmo sword, and
the same cuffs. It entwines with
a snake and a wolf. It is also Christian.

Fig. 24 Two Panels from the Snartmo Sword.

Compare with f. 22.

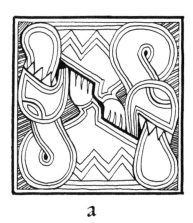

a

b

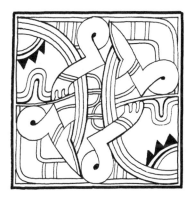

IONA, then, was the chief centre of the Irish church, traffic streaming through her between her mother centres Derry and Durrow, and her daughter foundations, Lindisfarne and Durham. Through her flocked hordes of English clerics, scholars, students seeking sanctuary, illumination or training at any of a vast number of monastic cities famed throughout Europe. And in Iona they mingled with the constant flood of peregrination to bring the good news to the Picts, to the Gauls, to the Britons, the Welsh, the Cornish, the Armoricans or Bretons; throughout the sixth century they established Celtic Christianity and linked it with the Coptic church, the Eastern, the

Greek, and with a characteristically Celtic
attribute of self-immolation converted
into *imitatio Christi*, for the sake of
catholicity, maintained their Patri-
cian link with Rome.

B Y 450, when the Angles, Saxons and
Jutes arrived in the wake of the
Roman withdrawal from Britain, the
metropolitan see of Armagh was already
busy with all the bishops Patrick had
appointed: reportedly 350 before he had
finished. A generation later Armagh had
monasticized, and Ireland embraced the
ideal of hermitage and evangelical pilgrim-
age to Britain, whence Patrick had come,
and to Gaul, where he had studied for the
priesthood at Lérins. During the sixth
century, Finian founded Clonard with

close ties to the Celtic Church of Wales. Clonard was instituted in the light of the teachings of the Welsh Cadog and Gildas, which passed on to Finian's pupils, Molaise of Devenish; Aidan of Ferns, Molaise's lifelong friend who in turn studied under David of Wales; Brendan of Clonfert, the Navigator, who certainly sailed to Britain; Ciaran of Clonmacnoise; and Columcille (St Columba) of Derry, Durrow, Kells, and Iona.

COLUMCILLE founded Iona in 565. A young Columbanus, pupil of Comgall of Bangor trained with him in the field; he joined the mission of Columba to the Picts of Inverness, and during that mission may have witnessed the adoption of Pictish animal symbols such as the eagle, bull, snake and dog by the

early Irish Schools. About this time the
Cathach, or 'Battler' of St. Columba was
produced, with the first animal head
in Celtic art, f. 19. It is assimilated into
the formal idiom of Ultimate La Tène,
as a zoomorphic terminal to a single
spiral. The jaws are treated as divergent
trumpet spirals elsewhere in the decora-
tion, filled with black in a La Tène tri-
angle of three curved sides: a convex, a
concave, and a curved edge compounded
of both types. This black area is relieved
by a lentoid counter as in La Tène enamel,
traditionally derived from Bronze Age
repoussé metalwork. The motif is
sained, meaning made holy or blessed
with the sign of the cross as were the
stone slabs which Columba encountered

throughout Pictland. These animal sym-
bol stones were decorated on the one side
and sained on the other with the sign
of the cross.

The Columban mission to the Picts
having been successfully concluded,
Columbanus launched a long series of
foundations among the Merovingians,
Burgundians, Alemanni, and Lom-
bards, from 591 to 613, including major
centres such as Annegray, Luxeuil and
Fontaine in the Vosges, leaving Gallus
to found what was to become one of the
best known centres of culture in Europe,
the abbey of St. Gall on the shores of Lake
Constance. Columbanus crossed the Alps
to found Bobbio in 613.

Fig. 25 Geometry of Hintschingen Motif.

a *Compass-drawn layout, 7 x 3 grid.*

b *completed geometrical layout.*

fig. 26 continued from f. 25.

a The same, woven.

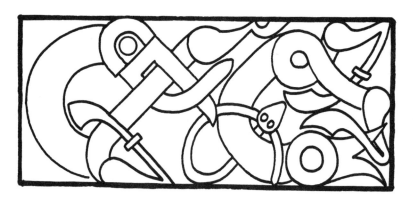

b Finished treatment.

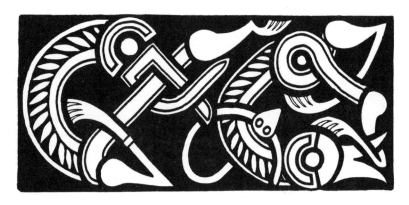

Fig. 27 Hintschingen Variation, no. 1.

a *Griffin, snake, griffin.*

b

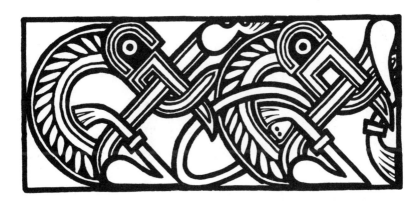

Fig. 28 Hintschingen Variation . no. 2.

a Wolf, wolf: compassdrawn set-up lines

b legs, feet and upper beak freehand.

Fig. 29 Hintschingen Variation, no. 2.

a The same, to completion.

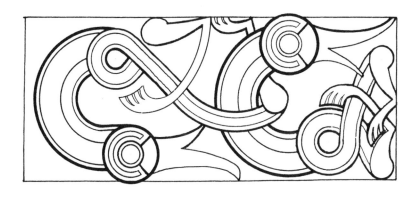

b Compare this wolfhead with that in f.9.

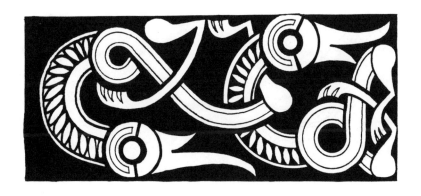

fig. 30 Hintschingen Variation, no. 3.

a Compass-drawn curves on 7 x 3 grid.

b Completed layout, compass drawn!

Fig. 31 Hintschingen Variation, no.3.

a Woven.

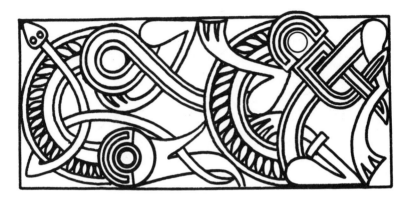

b Snake, wolf, griffin.

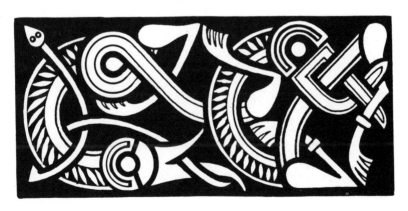

fig. 32 Hintschingen Variation, no. 4.

a Compass-drawn layout on 7x3 grid.

b

Fig. 33 Hintschingen Variation no 4.

a Woven.

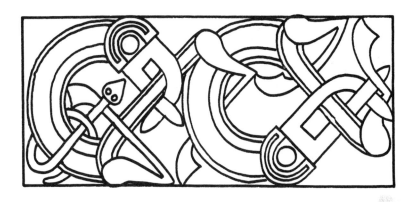

b Final : snake, griffin, griffin.

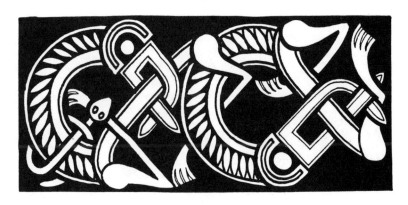

Fig. 34 Hintschingen Variation no. 5.

a Snake, wolf, wolf.

b Final.

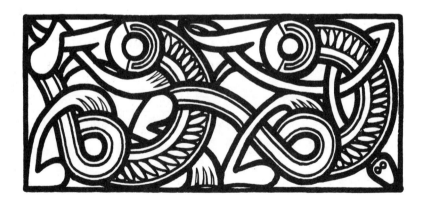

Fig. 35 Border from Sutton Hoo Brooch.

a

b

c

d

The griffins here form a running border, a theme adopted with great relish by the Gospel illuminators. The head, filled in at d, is attached to a broad ribbon body, b, from which sprout a fore and hind leg, c, complete with pear-shaped shoulder joints or drumsticks.

[57]

Fig. 36 Analysis of Sutton Hoo Brooch
 Border Weave.

a The two sides are
paired in mirror symmetry;
in Celtic animal pattern, how-
ever, the weaving should be
continuous, and therefore
reversed from one side to the
other, which is not so in
this case. Here is the design
as mirrored on the brooch, to
the left, while to the right is
the correct weave with a cross-
over on one side reversed to a
cross-under on the other.
See f.2.

b Weave must be
over-under, not over-over or
under-under. Corrections to
be made marked x.

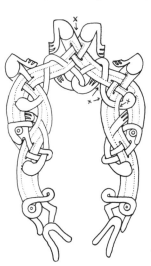

B ELTS, buckles and brooches were some-
thing special in former times. Worn
to enhance the spirit of the wearer, jewel-
ry had a mystique, a ceremonial quality.
Dressing up was a way of life. Every orna-
mental detail had a ritual signifi-
cance. Decorations were bestowed as recog-
nition of exceptional valour or service,
not bought. They were only to be
acquired through a demonstration of
nobility of spirit, or supplied for a
special occasion, or as a gift, and
were prized accordingly. Rather than
being preserved to give prestige to an
heir, treasured ornaments were bur-
ied with their owner, so bound up
were they with his or her personal
power and charisma.

Treasure would not stay long underground
if thought of only in terms of money value.
It was buried rather because it belonged to
the spirit of the departed, and not to the
world this side of the grave. Nor did the
owner's death suddenly elevate an item of
wardrobe or armory to the status of a sac-
red relic. We may be sure the personal accou-
trements of a burial hoard were revered as
talismanic witnesses to the spirit so
adorned while yet in the flesh.

IN traditional societies there is no sharp
line between secular and sacred art.
Among natives of Northern Europe, the
early Columban monks demonstrated their
claim to spiritual authenticity by recogniz-
ing, *saining* and converting traditional art
forms they encountered, and expanding

the repertory of ornamenting Gospel
books from Irish La Tène spirals only, to
a universal art of ornament a good millen-
nium ahead of its time. Wherever they went
their art spoke first of the universality of
the message contained in the book they lived
so wholly by.

IN order to merit the respect of people whose
 traditions they encountered, they had to
out-master the existing traditional masters,
as for instance those of the Anglian court at
the time of Fursey, first Bishop to the East
Anglians at Yarmouth under King Sigebert
successor of Readwald, about 630. Similar
pieces to those of Sutton Hoo may well have
constituted part of the endowment of
the monastery at Burgh Castle, whence
they might have found their way to Durrow.

Fig. 37 Transition from Sutton Hoo to Durrow.

a Design from Sutton Hoo sporran.

b Half of the Sutton Hoo design, one
animal of the unit shaded in.

c One animal, extricated from the other.

d One animal from the Durrow border.

e The Durrow border.

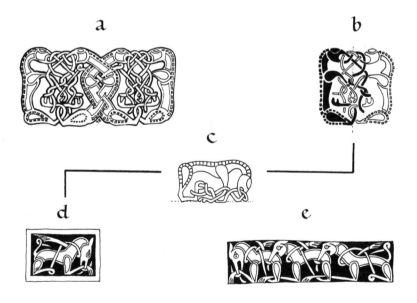

CHAPTER III
From Sutton Hoo to Durrow

F COURSE THERE IS NO DIR-
ect link between the Sutton Hoo
Hoard and the Book of Durrow,
historically, to my knowledge.
Nor do we know the date for sure of either. The
two may well be contemporary, or be working
from a common model. Under the abbatial
Bishop Fursey or his brother Foillan who suc-
ceeded him to the see of East Anglia about 644,
Irish practices likely prevailed. The pagan
ship burial may have been a cenotaph for a
personage given Christian burial elsewhere,
such as Sigebert.

Fig. 38 The same, the alternative derivation.

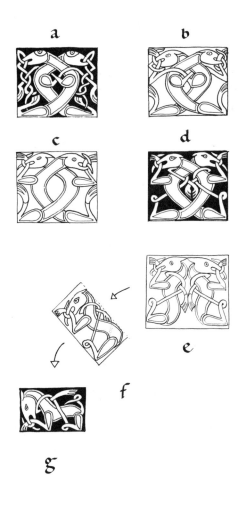

Fig. 39 Repeat Motif from centre of Sutton Hoo
 Sporran design.

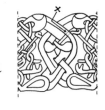

As in f.36, the principle of
Celtic knotwork – reversal of weave in
an otherwise mirror symmetry – is a
absent from the Sutton Hoo exam-
ple. The legs cross all right, but

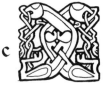

the weave is clumsily fudged at
the neck, a. See f.37, a, also. b
 The Celtic version would
be either a reversal of the weave, b;
or an uncrossing of the forelegs, c,
which would allow the mirror c
weave.

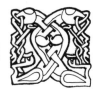

 A more Germanic resolution
would be to interlace the necks the
same as the waists. If, as assumed, d
the Anglo-Saxons introduced the
Celts to Germanic interlace as evidenced by the link
between Sutton Hoo and Durrow, why the gaffe here?

Fig. 40 Durrow Animal, Freehand Method.

If you look closely at the Book of Durrow
you may discover that there is a
calligraphic stroke order in the a
pen drawing. This is a mnemonic
device which if memorized, en– b
ables the design to be drawn free–
hand. The layout may begin c
with a dot grid 'W', to locate the
legs, a; tail and rear leg, b,c,d. d
Notice how the strokes fall into
place springing one from an– e
other. Also we see a key line
emerge between the lower jaw f
and loop of the hind leg, e, f.

 And so to finish. The key g
line is not unique, though it
is characteristic of Irish scribal h
art: see the Snartmo Sword, f. 24.

Fig. 41 Durrow Border : two unit repeat.

Within the stroke order variations are
possible, and up to the
individual, as here,
where the border is to
be read from left to
right, so we may in-
troduce the head and
the lower jaw key line,
b,c. The first thing to
note carefully is the
construction of the
hind-leg, for in fact

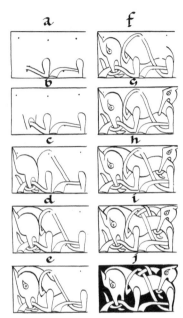

a foreleg belonging to a second beast, entering
stage right, is introduced here, at a.

Instead of a tail, therefore, there is a
rump-biting head, g-i. Its lower jaw crosses
over its upper, passes under the rib cage of its
predecessor, and over the latter's rear ankle.

[67]

Fig. 42 The same, continued.

a-e. This is the tail end of this border, the

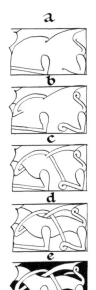

a right-hand terminal.

Again the stroke order is somewhat different. The order of a single unit does not need to proceed from left to right as here. The left-hand key line running through the border slices off the head, with no regard for representational verisimilitude. Unlike the common line between the upper and lower halves of the Snartmo sword-hilt design, f. 24 a, here the form is shattered in the sense of Meister Eckhart's idea of cutting through the images of nature to reveal the underlying, causal level. This apparently 'Germanic'-style animal is no such thing!

Fig.43 First Border from Book of Durrow.

a Two units from Book of Durrow,

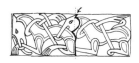

left and right hand terminal units, with key
line outlined for emphasis.

b Three units constitute the first border
from the Book of Durrow, in which a repeat-
able central unit is inserted between the two
end units, utilizing the keyline to produce
a tessellation or tile design suitable as a
circular repeat for an armband or the
rim of a bowl.

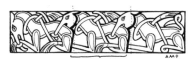

repeat.

[69]

Fig. 44 First Border from the Book of Durrow.

a-d Calligraphic, freehand method of con-
struction, showing the stroke order in the
building-up of the pattern.

The advantage of this method is to reduce
calculation and
eliminate depen-
dency on mechani-
cal aids. To master
the method, a
little practice is
needed. But then,
this is true of any
calligraphic art
form.

a

b

c

d

With practice, then, the Celtic artist
learns to see - or more truly, to read the
model at a deeper level than the superficial

Fig. 44 The Same, Continued.

e-h Stroke order, to completion.

appearance of the design, as for instance, its semblance of 'Germanic' animal style in the hook of the jaw. This has led to much speculation

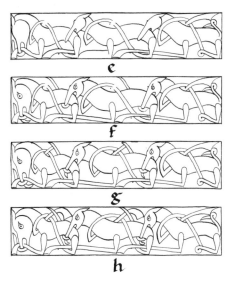

as to the 'Anglo-Saxon' element in the Book of Durrow, when as we have seen, the Alemannic gold foil cross provides a model in many ways closer to Celtic design than the legless creature of the clasp from Sutton Hoo. Even granting a semblance of relationship, what about the dissimilarities?

e

f

g

h

Fig. 45 Two Panels based on first Durrow Border.

a First panel, mirrored symmetrically on horizontal centre line axis.

b,c,d The lower half of the panel, with the weaving reversed, which interrupts the key line.

e The second panel, rotated 180° whereby the weave remains the same while also retaining the key line.

a

b

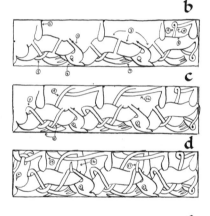

c

d

e

Fig.46 Second Border from the Book of
 Durrow.

Here is an example of that equivalence
of symmetry said to typify Celtic art :
the corners marked 'x' are different.

a

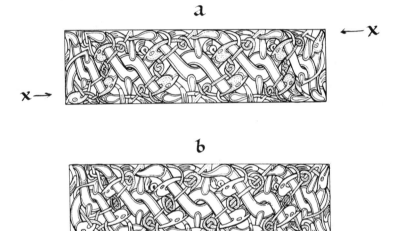

←—x

x—→

b

The asymmetry is a deliberate variation
indicating a virtuoso's improvisation, a
provocative aside which is suggestive of a
quite different pattern, to another designer.

[73]

Fig. 47 Second Durrow Border, Analysis.

There are two waves of animals overlap-
ping, one set yellow-bodied, one red-bodied.

a

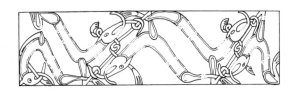

b

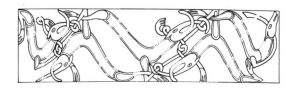

The foreleg drumsticks are all green.

a Red wave.

b Yellow wave.

Red and yellow are the traditional
colours of Celtic champlevé enamelling.

Fig. 48 Seven Variations from the Second
 Durrow Border.

a

b c

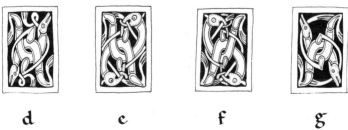

d e f g

[75]

Fig. 49 The Third Durrow Border.

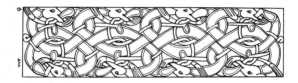

a

b

c

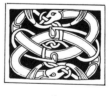

d

fig. 50 Motifs from the Third Border.

a Unit from the third Durrow border.

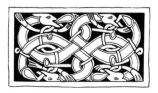

b Variation of same , f. 49 b rotated 90°

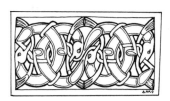

and repeated to form a different border.

Fig. 51 Third Border from Book of Durrow.

a-o *The third animal border from the Book*

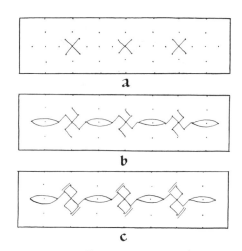

a

b

c

of Durrow has a definite square grid of dots –
8×2 – underlying it. It begins with the cross,
a, the fylfot and interstitial lens, b, setting
off the key structure on these symbols, from
which the strokes may then be laid in, c-o.
With a little practice the whole design may
be readily memorized and executed free hand,
and spontaneously.

FIg. 51 The same, continued, d - g .

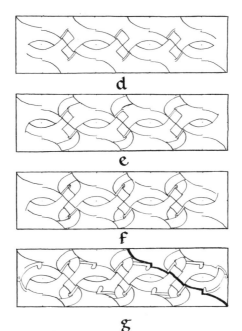

d

e

f

g

This design has a variety of keylines, as
illustrated at g , which gives the pattern the
additional attraction of being useful as a
tessellation design.

Fig. 51 Continued , h-k.

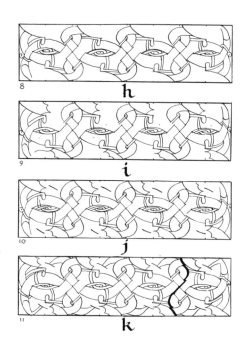

8 **h**

9 **i**

10 **j**

11 **k**

Another tessellation keyline is shown, k.

ƒig. 51 continued , l–o , to completion.

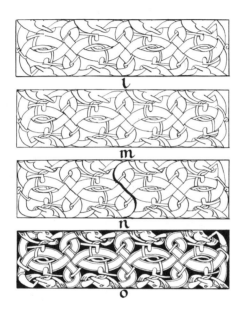

ι

m

n

o

Another tessellation keyline is shown, n.

Fig. 52 Motifs from Hintschingen,

 Sutton Hoo & Durrow, compared.
a Hintschingen , b Sutton Hoo.

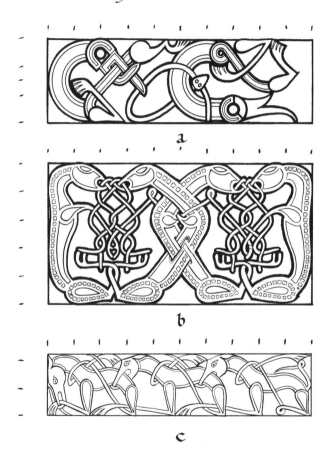

a

b

c

c Durrow.

Fig. 53 Sutton Hoo Sporran Motif.

Fig. 54 Two Dogs from the Durham Cassiodorus.

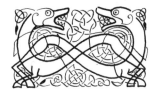 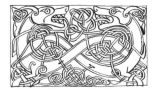

Fig. 55 The same, broken down.

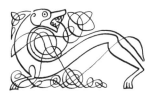

WHEN the Irish monks had finally secured the conversion of the Angles and the Saxons in the first part of the seventh century , they had already been in contact with Germanic animal art through the mission of Celtic Christianity throughout what had been, before the Romans and their successors the Germanic tribes , Celtic Europe. The Burgundians, Visigoths and Franks were already Christianized , and the Columban mission to these territories was primarily one of rein-forcement. At the turn of the seventh century, then , Columban scribes would have begun the task of studying the forms of Germanic art , especially where they found them in an existing Christian context. The art of the Irish and British Celts , the Pictish animal symbols, then Lombardic knotwork

appear in the iconography of Christianity
in Ireland in the sixth century, reflecting
the order in which the various people repre-
sented had been converted through the Colum-
ban monasteries. The traditional forms
of these peoples, and of all such forms
only the most intelligible were converted into
the emergent canon.

Knotwork was embraced for its formal and
symbolic intelligibility, not limited to any
one people. In the sixth century, as the Germ-
anic animal style began to be the dominant art
form of Northwest Europe, a new form of art
for a new form of social order emerged - animal
knotwork in the form of serpentine filigree and
long beak-snouted animals. The new order
was the federation of German tribes - all but
the Saxons and Frisians - under the Mero-

vingian Franks, which had begun with Clovis
in 497, who had converted to Christianity in
fulfilment of an oath made to obtain vic-
tory in battle, and was followed by a great
number of Frankish chieftains. The Burgun-
dians and Visigoths had already converted
before the collapse of the Roman empire,
and so naturally the Celtic monks viewed
the emerging order as the victory not of
the German tribes but of Christ, a victory
they rejoiced in, as the soldiers in the
spiritual battle. They celebrated their
own victories for the Celtic Church by
taking over the art forms of their new
members, and Celticizing the new forms.
Thus, when the Anglian Court welcomed
the Irish brothers Fursey, Foillan and Ultan
in 630, Celtic animal pattern was then born.

CHAPTER IV
Dog Designs

AT THE TIME OF EARLY Christianity, Germanic art had a style of animal pattern which the Irish and Scottish monasteries adapted and developed in a direction of anatomical integrity. Having clarified the anatomy of the animal form, a new development occurred that distinguished between quadruped and biped. With this logical separation of bird from beast, the hound and heron of Celtic animal pattern emerged to become the mainstay of Irish as distinct from Saxon tradition.

Fig. 56 Quadrupeds from Cambridge, Corpus
 Christi College, ms. 197.

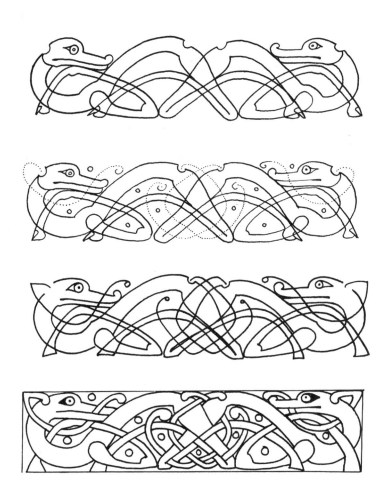

Dog Designs

Fig. 57 Animal Border, Durham ms. A.11.17.

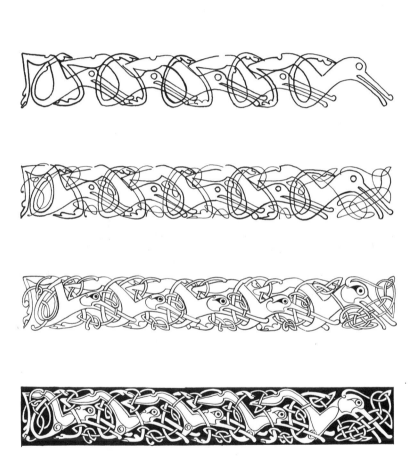

Fig. 58 Slate Motif-piece, Dungarvan, Waterford.

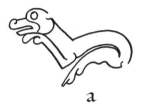

a

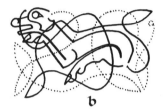

b

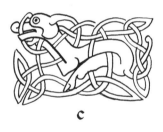

c

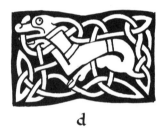

d

Fig. 59 Seven Irish Motif-Pieces.

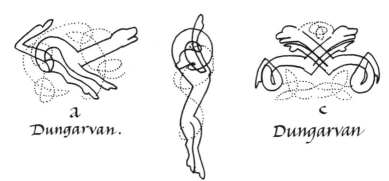

a
Dungarvan.

c
Dungarvan

b Strokestown Crannog.

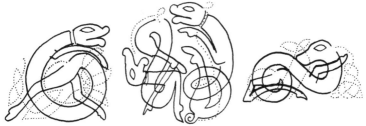

Christ Church Place, Dublin— d, e, f.

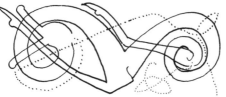

High Street, 8, Dublin.

Fig. 60 The Same, to completion.

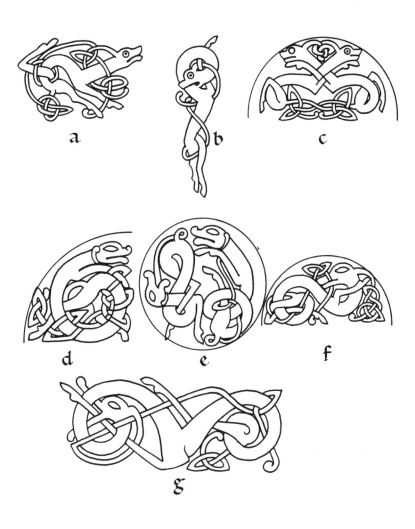

a

b

c

d

e

f

g

Fig. 61 Two Dogs , Christ Church Place , Dublin.

a

a line construction.

b

b completion of same. Note the key stroke in the form of a cross at the intersection of the necks and forelegs.

Fig. 62 Eight Irish Motif-Pieces.

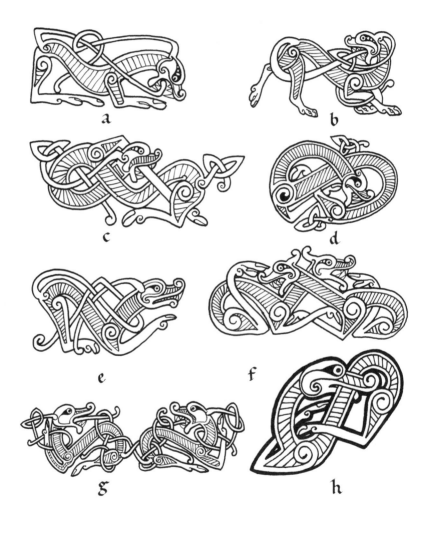

a

b

c

d

e

f

g

h

Dog Designs

Fig. 63 Constructions for the Same.

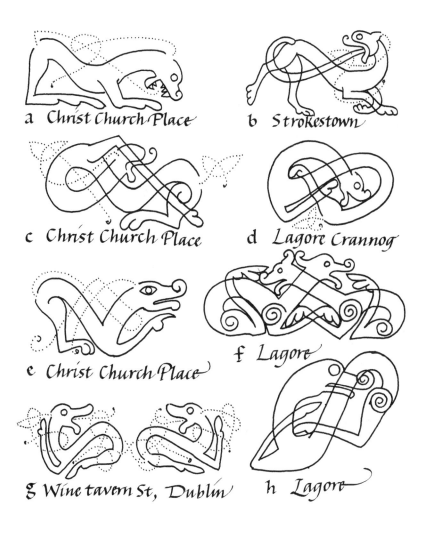

a Christ Church Place

b Strokestown

c Christ Church Place

d Lagore Crannog

e Christ Church Place

f Lagore

g Wine tavern St, Dublin

h Lagore

Fig. 64 Six Designs from Irish Stone Crosses.

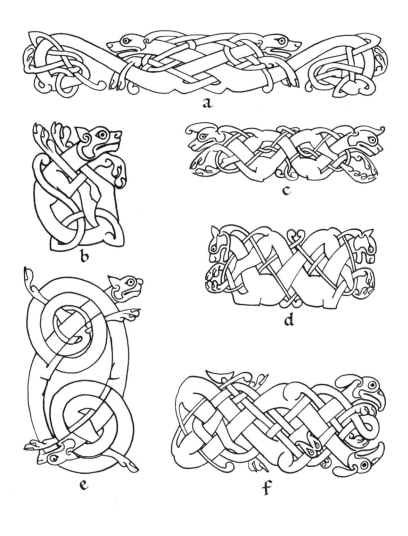

a

b

c

d

e

f

Fig. 65 Constructions for the Same.

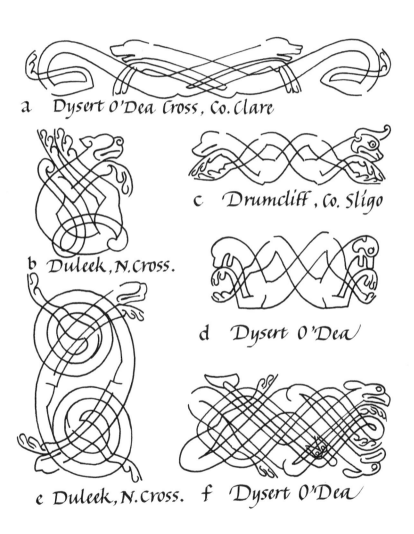

a Dysert O'Dea Cross, Co. Clare

b Duleek, N. Cross.

c Drumcliff, Co. Sligo

d Dysert O'Dea

e Duleek, N. Cross. f Dysert O'Dea

Fig. 66 Two Designs from Lindisfarne.

a c

b d

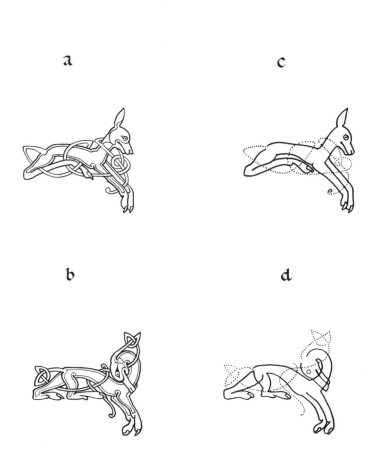

Fig.67 Lindisfarne Dog, full treatment.

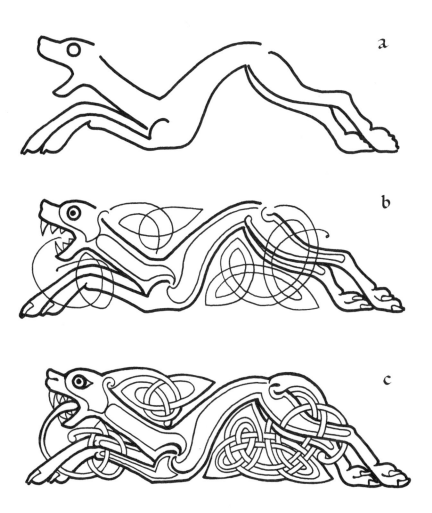

a

b

c

Fig. 68 Teardrop Space Filler, Lindisfarne.

Drop Shaped Dog Knot from Lindisfarne.

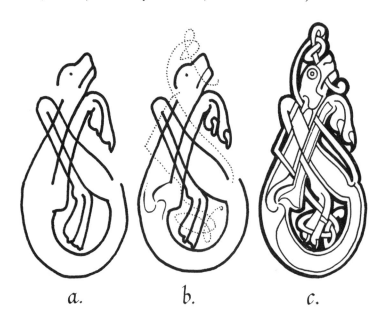

a. b. c.

This design is a simple loop body, with hind leg woven through fore leg and neck, a; add tail and ear lappet, b. The shoulder spiral is a triskele attached to the neckline by one arm, the other two set off the inline.

Fig. 69 Dog from the Book of St. Gall.

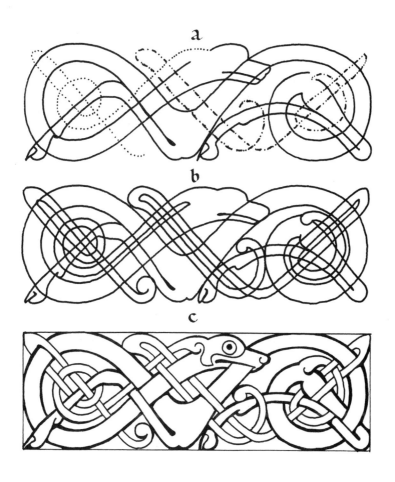

a

b

c

Fig. 70 Three Dogs from the Book of Kells.

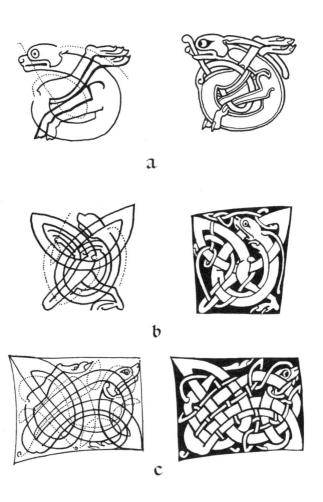

a

b

c

Fig. 71 Dog and Snake from Kells.

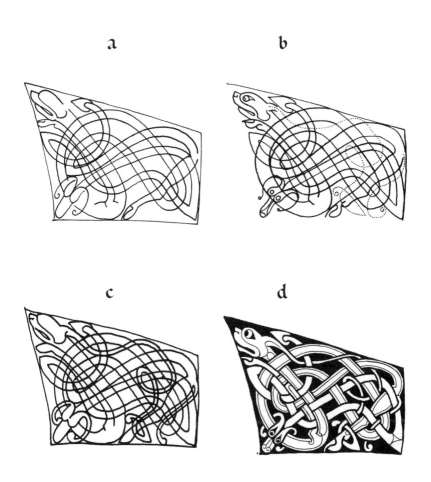

a

b

c

d

Fig. 72 Triquetra Knot Dog from Kells.

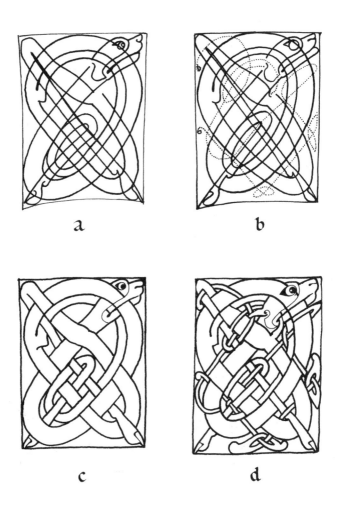

a

b

c

d

Fig. 73 The same, a variation.

This and the previous figure form a set, which illustrates the variables in a basic design. The obvious difference is the tail and the lappet from the ear, which form the secondary knots in the background. The forelegs spring from different points on the body, and loop around the back; in the case of the previous figure, it loops around the hind leg also. The faces weave differently, in a subtle way.

a b

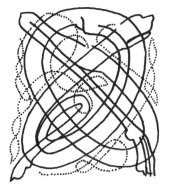 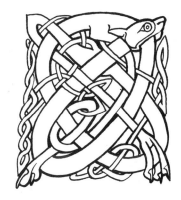

CELTIC animal pattern is quite obvious-
ly distinct from Germanic style II.
In Scandinavia the Germanic style develops
along its own lines, to be non-naturalistic,
fantastic and heraldic. In contrast to
this tendency, Celtic animal pattern has
a feeling for animal form, whether in the
whimsical tenderness of early Celtic
animal portrayal or in the purity of
natural line found in the duck-head
terminals of abstract spiral designs.
Integral sensitivity to natural animal
form distinguishes Celtic from Anglian
or other Germanic styles. It should also
be noted that the dog motif is the totem
of the *Dalriada* tribe of ancient Ulster
to which Columba belonged, the Scotti
of Argyll. It means faith, *doggedness*.

Dog Designs

Fig. 74 Two Designs from Lindisfarne.

a , b Triangular space filler

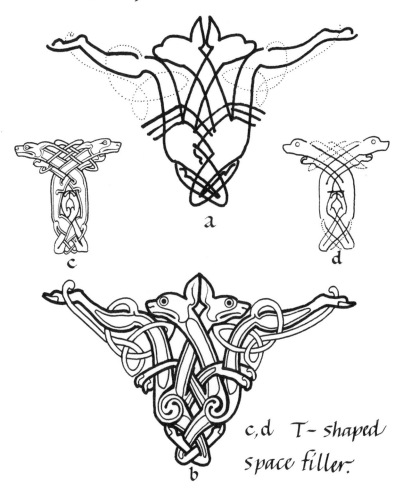

a

c

d

b

c,d T- shaped
space filler.

[107]

Fig. 75 Two Dogs from the Book of Kells.

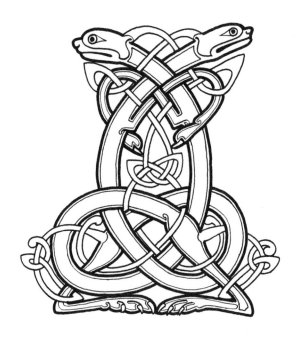

fig. 76 The same, Construction.

The lower part of these bodies is a
Josephine Knot.

Fig. 77 Border of two dogs from Lindisfarne.

a,b construction ; c final treatment.
 Rotational symmetry.

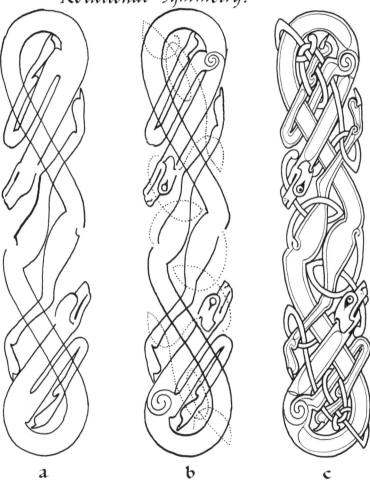

a b c

Dog Designs

Fig. 78 Fig. 78 Two-Dog Border from Lindisfarne.

An example of mirror symmetry.

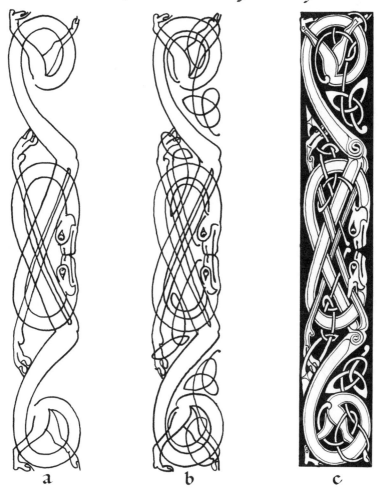

a b c

Fig. 79 Two-Dog Border Unit from Lindisfarne.

This pattern has rotational symmetry and also two tessellation key strokes.

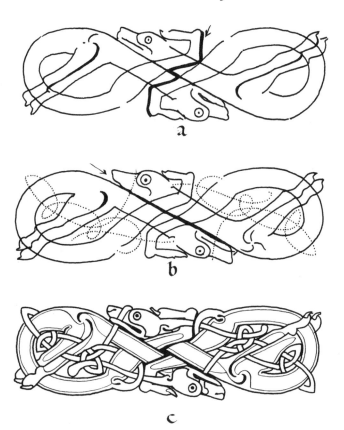

a

b

c

The forelegs share a keyline, too.

Fig. 80 Two-Dog Border from Lindisfarne.

These dogs have unicorn-like lappets.

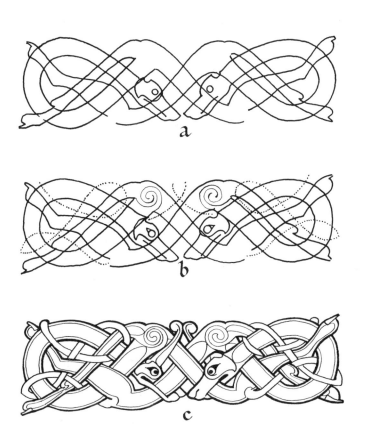

a

b

c

Notice how the weave reverses in reflection.

Fig. 81 Two-Dog filler from Lindisfarne.

In this irregular space filler, lappets form a ring.

a

b

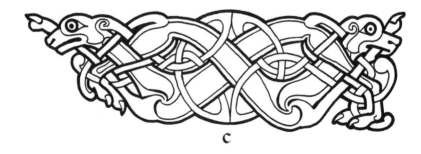

c

Fig.82 Two-Dog Border from Lindisfarne.

a Single dog, tongue knot, lappet and tail.

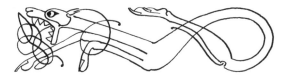

b Dog reflected on itself, mirror symmetry.

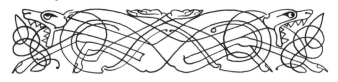

c Weave reverses with mirror symmetry.

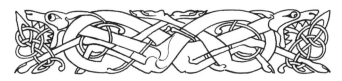

d Completed design.

Fig. 83 Two-Dog Knot from the Gospel book
of St. Gall.
The design is subtly asymmetrical.

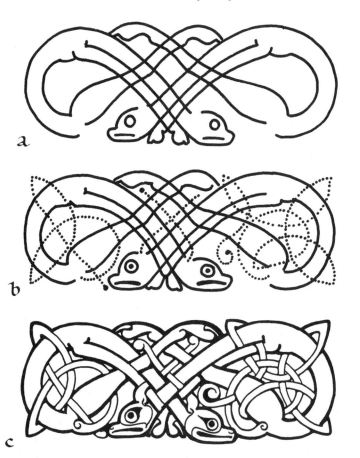

a

b

c

Fig. 84 Two-Dog Unit from St. Gall.

The dogs do not interlace, each is separate.

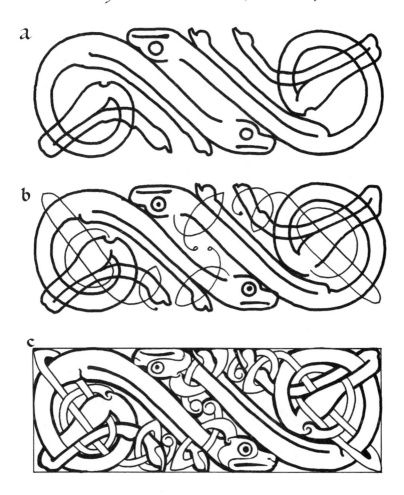

a

b

c

Fig. 85 Four Two-Dog Borders from St. Gall.

b,c,d provide an instructive study in

a

animal border variation.

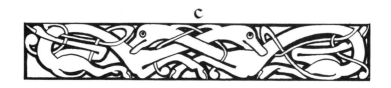
b

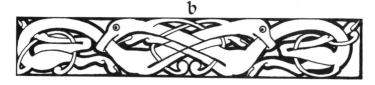
c

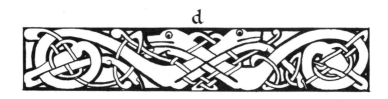
d

Fig. 86 The Same, constructions.

Compare f. 87 with a, here.

a

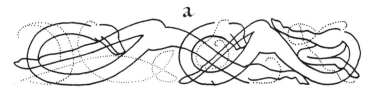

b

c

d

Fig. 87 Three-Dog Border, Book of St. Mulling.

a

b

c

d

e

Dog Designs

Fig.88 Two- and Four-Dog Borders, Kells.

a,b, Two dogs; c,d, Four dogs.

a

b

c

d

Fig. 89 Two-Dog Border, Kells.

a

b

c

d

Fig. 90 Two-Dog Border, St.Gall.

An unusual 'spotty dog' treatment.

a

b

c

d

Fig. 91 Spiral Dog Border, Kells.

An example of a single unit repeat.

a

b

c

d

Fig. 92 Two-Dog Irregular Space filler, Kells.

a

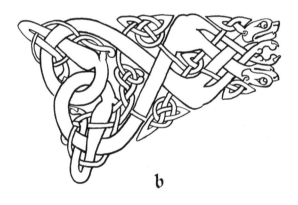

b

Fig. 93　　　　Two-Dog-and-Eel Space Fillers, Kells.

The fish-tailed eel is the monk's

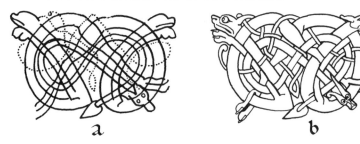

a　　　　　　　　　b

version of the serpent.
Like the snake, the eel is a 'slippery

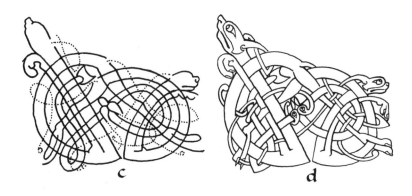

c　　　　　　　　　d

customer', symbol of cunning, craft or skill. Its
gills may be extended as lappets.

Dog Designs

Fig. 94 Two-Dog Panel, Christ Church Place,
 Dublin.

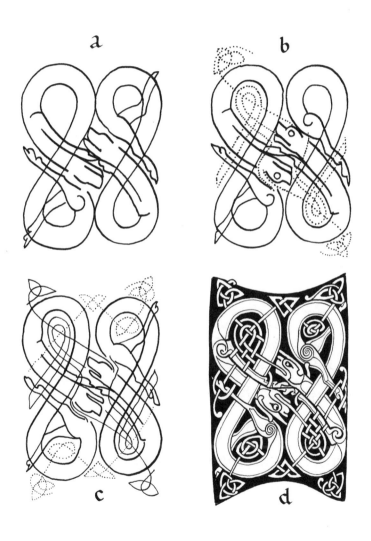

a

b

c

d

Fig. 95 Four-Dog Panels from Lindisfarne.

These two panels are an instructive study, in the manner by which the basic design, a, may be varied – compare the necks and hind –

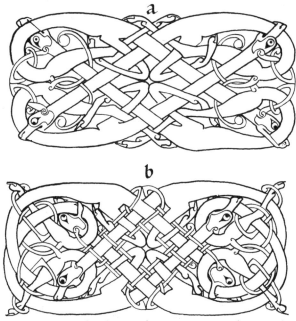

a

b

quarters – and likewise the way in which the whole may be made more complicated, by extending the ear-lappets, b.

Fig. 96 The same , Constructions .

We can see here also how to join the two halves above and below the midline – by crossing the necks, a, b; or by crossing hindquarters, b.

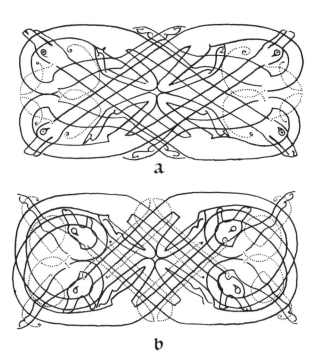

a

b

Ear or tail lappets may also cross over. A two-dog border may thus become a panel.

Fig. 97 Four-Dog Panel, Dysert O'Dea Cross.

The dogs have forelegs tightly woven.

a

b

CHAPTER V

Dog - and - Bird Designs

NOTHER INNOVATION which distinguishes Celtic animal patterns from any other is the introduction of the bird motif. This arose of necessity in Celtic art to compensate for degeneration of the Germanic quadruped, as seen in f. 18 where it trails off into a hind leg only, or even a legless body and an unrecognizable head. To the Irish monks such ambiguity only advertized the bankruptcy of the spirit that was reflected in such unintelligibility.

Fig. 98 Two Birds , One Dog , from Lindisfarne.

a The dog.

b One bird facing left.

c Bird facing right.

Fig. 99 The Same , combined .

a,b *Two birds ; two birds with dog.*

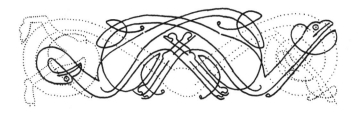

c *Woven together.*

Fig. 100 Two Dogs, Two Birds, Lindisfarne.

The design has rotational symmetry.

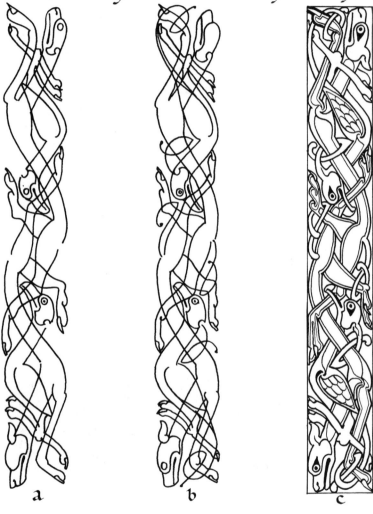

a b c

Fig. 101 Two Birds, One Dog, Lindisfarne.

Similar to f.99 , but one bird reversed.

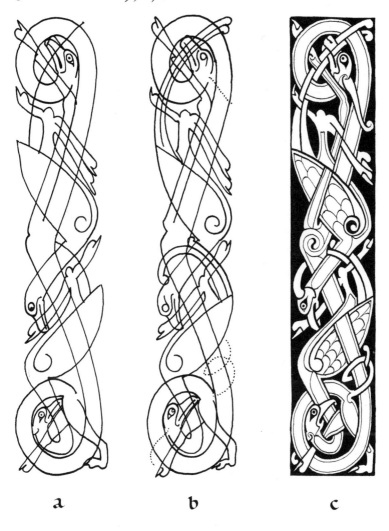

a b c

Fig. 102 Dog and Bird, Lindisfarne.

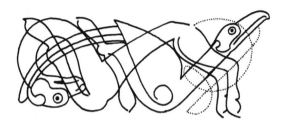

a

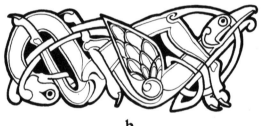

b

The tail of the bird is a split ribbon,
providing a keystroke; also, the common
line of the dog's hind legs. The underside of
the bird's neck and beak, the lower edge of the
wing, and belly/toe line are key strokes too.

Dog-and-Bird Designs

Fig. 103 Two-Dogs-and-Two-Birds.

The Book of Mulling.

a

b

c

d

Fig. 104 Bird from Book of Kells.

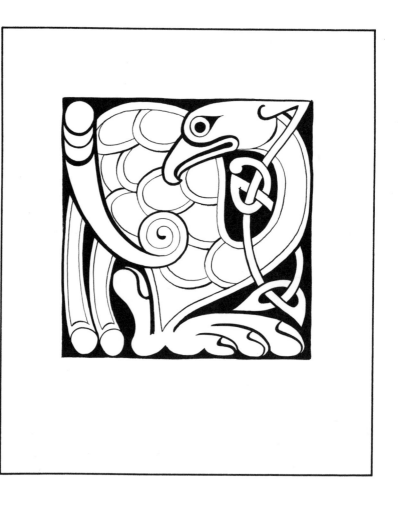

CHAPTER VI

Bird Borders

THE BIRD OF NORDIC ART WAS the eagle of Odin, derived from the imperial crest of the Roman legions. But the Celts had always held birds sacred as messengers of the otherworldly, supernatural realm. In early Christianity, the eagle became the emblem of St John the Evangelist, its Celtic form derived from Pictish art. In the patterns the long-beaked waterbird, crane, cormorant or heron, also appears. This bird of two worlds, air and water, is the signature of *crien*, Greek root of *Christos*.

Fig. 105 Evangelist Symbol, Eagle.
-Kells -

This Eagle has four wings, as do Cherubim.

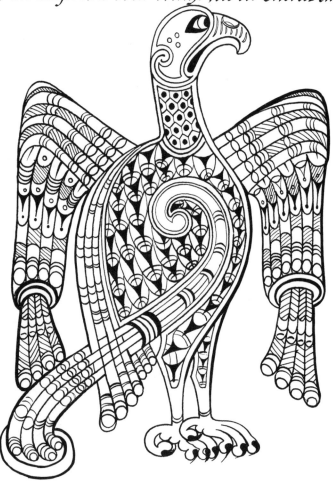

Fig. 106 Eagle, Kells.

Like the previous figure, this bird has

an extra two wings.

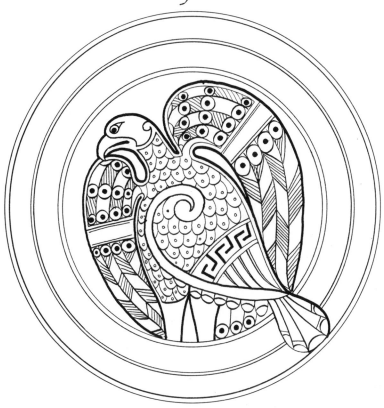

Fig. 107 Bird with Fish, Kells.

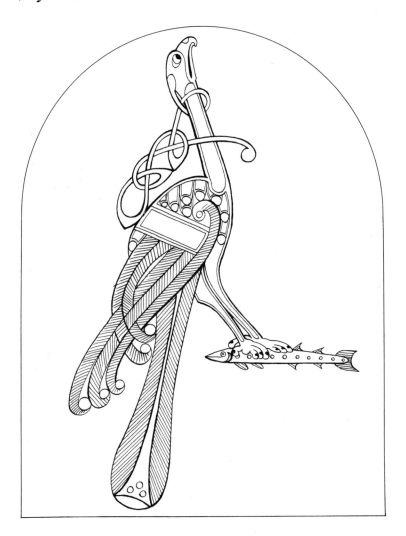

Fig. 108 Birds from Kells and Armagh.

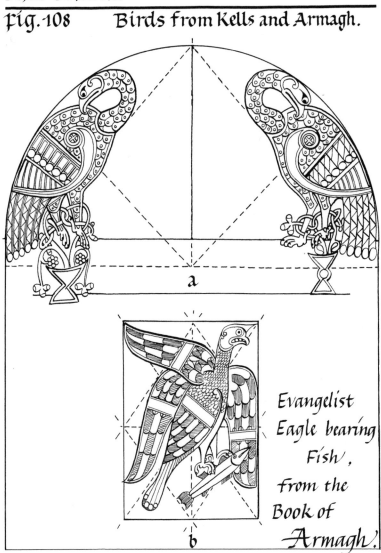

a

b

Evangelist
Eagle bearing
Fish,
from the
Book of
Armagh.

Fig. 109 Bird from the Book of Kells.

Viewed simultaneously from side and rear.

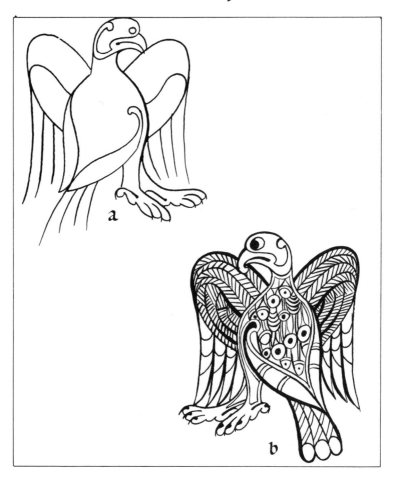

Fig. 110 Two Birds from the Book of Kells.

These birds' necks form a crab knot.

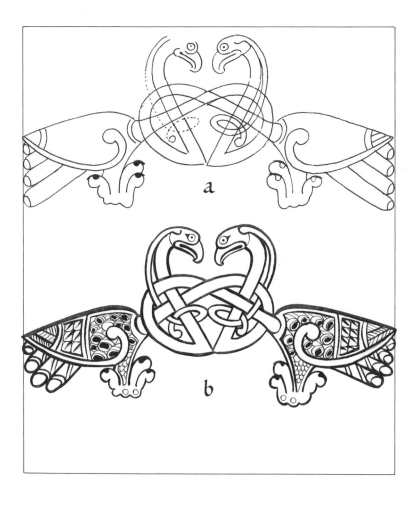

a

b

Fig. 111 Bird from Lindisfarne.

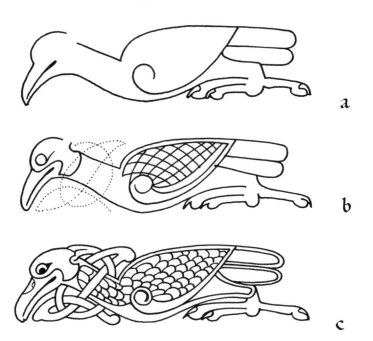

a

b

c

Fig. 112 Bird Border Terminal, Lindisfarne.

a

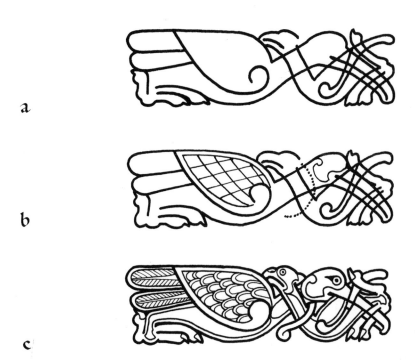

b

c

Fig. 113 Bird Border, Lindisfarne.

a

b
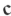

c
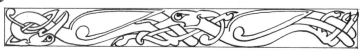

d

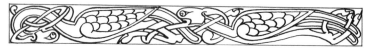

Fig. 114 Bird Border, Split Necks,

Lindisfarne.

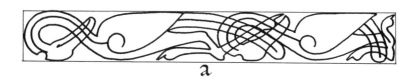

a

b

c

Fig. 115 Bird Border, Split Tails.

Lindisfarne.

a b c

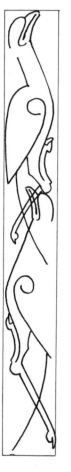
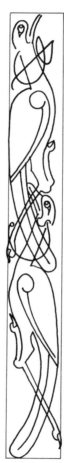
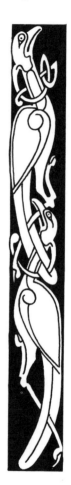

Fig. 116 Bird Border, Lindisfarne.

This beautifully balanced pattern of birds with their heads tucked under their wings reads equally well upside down. The artist has given us the design in simple form,

a

b

without lappet knots except at extreme right.

c

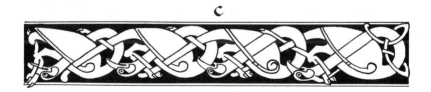

Fig. 117 Border from Lindisfarne.

This particular pattern appears also in the Book of Lichfield which is dedicated to St Chad, and may have been copied from the Book of Lindisfarne. Chad was a pupil of Aidan of Lindisfarne, in the Columban tradition. He

a

b

c

was Bishop to the East Saxons and, later, the Mercians.

Fig. 118 Triquetra Bird Design
 from Lindisfarne.

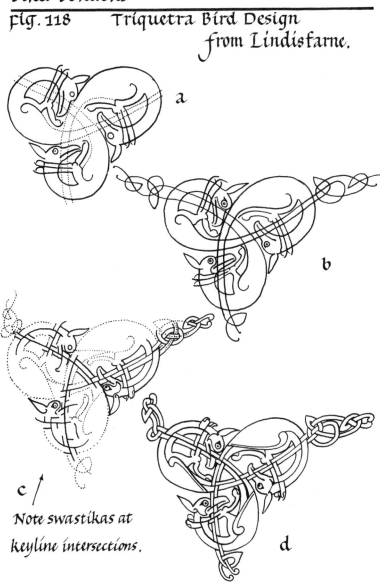

a

b

c

*Note swastikas at
keyline intersections.*

d

Fig. 119 Celtic Warrior and Bird, Kells.

a Construction.

b Finished version. The warrior has a spear in his left hand and a Celtic-style targe shield in his right hand. This may symbolize the struggle of the spirit armed with penetrating insight and guarded by sound judgement against flightiness, the sometimes manic

a

flight of thought and imagination, that assails the undisciplined monk.

b

CHAPTER VII
People Patterns

INALLY WE COME TO THE last type of animal pattern – the human form-midway between the creatures of the earth's surface, snake and dog, and the birds of the air, creatures of the heavens. If the serpent, as eel for instance, is water, the bird is of the air; the dog is of the earth. This leaves the element of fire – the spark of inspiration – as the proper reference of the people patterns. Together they form the cross of psyche – body, heart, imagination, and identity.

Fig. 120 Wrestlers, Motif-Piece, Garryduff.

a

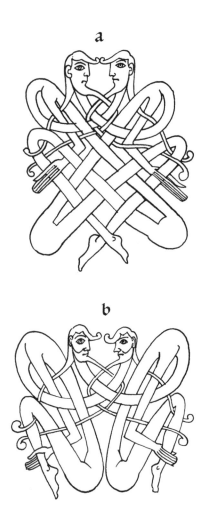

b

Fig. 121 The Same, Constructions.

a

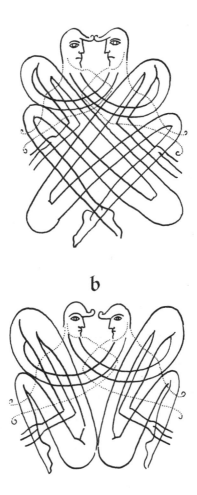

b

Fig. 122 Panels from Irish Crosses.

Monasterboice, a ; Kells, b ; Ahenny , c .

a

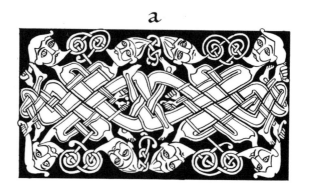

b c

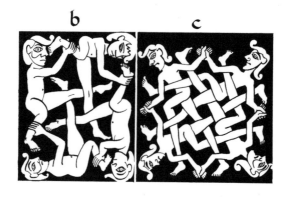

Fig. 123 The Same, constructions.

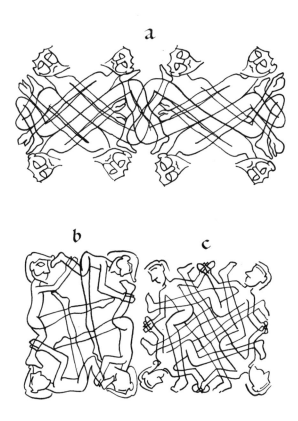

a

b c

THE END